Divinely Different

One Man's Enchantment With Santa Fe

Poetry by Stephen Daingerfield Dunn

Photography by Richard Bettinger

Divinely Different

One Man's Enchantment With Santa Fe

Poetry by Stephen Daingerfield Dunn

Photography by Richard Bettinger

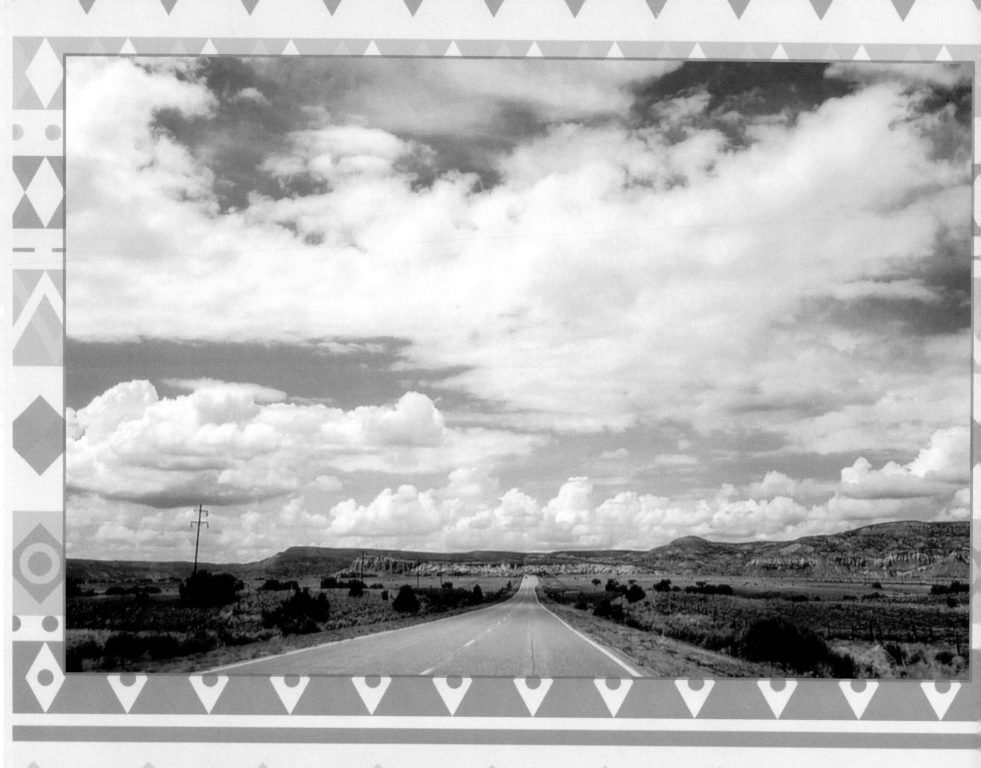

Santa Fe Magic

Few are the cities in our country,
that can transport us far away.
Creating a foreign world,
that is unlike any in the U.S. of A.

However, the mecca that holds the title,
as the best in the land,
is in the land of enchantment,
that has captured the heart of many a man.

Santa Fe, Oh Santa Fe!
where everything is magical and unique.
From the adobe Architecture,
to the American Indians on the street.

Creating their own special cuisine,
unlike anything ever tasted before.
With a dash of red or green chilies,
that is impossible to ignore.

Vying to be the nation's art capital,
in this place of sunsets and sand,
This magnet to many of the finest artists,
ever known to woman or man.

Two hundred or more galleries,
that hold art that delights.
A treat for collectors and visitors,
most every Friday night.

With roots deep into Catholicism,
there is much that is scared and rare.
For you can always find a holy space,
where you can say your silent prayers.

With sunsets that capture your heart,
and an abundance of divine cuisine,
There's always a wealth of entertainment,
in this tiny cosmopolitan scene.

Oh, my city so different,
You are the girl of my dreams.
For everything is even more spectacular,
than I could possibly ever make it seem.

My Love, My Santa Fe

Golden sun
on mountains of snow.
A land of enchantment
I've come to know.

Surrounded by magic
cast by the tribes.
Close to my heart
sending out loving vibes.

Unique in its beauty
subtle, its allure.
A place of distinction
my soul it does cure.

Why does it call me,
this country I adore?
With its ancient legends
and tales of lore.

With heavens so blue
they startle the eye.
Stars you can touch
in the midnight sky.

Artists abound
all genres expressed.
People being original,
nothing repressed.

Though suburban in size
this city quite different.
Artists with abundance
amazingly significant.

Original cuisine
over which they labor.
Where the Indian intertwines
with its Spanish neighbors.

A land like no other
that charms my soul.
A land of enchantment
where magic unfolds.

My Santa Fe love
fills my every dream.
Where life appears
just as it should seem…

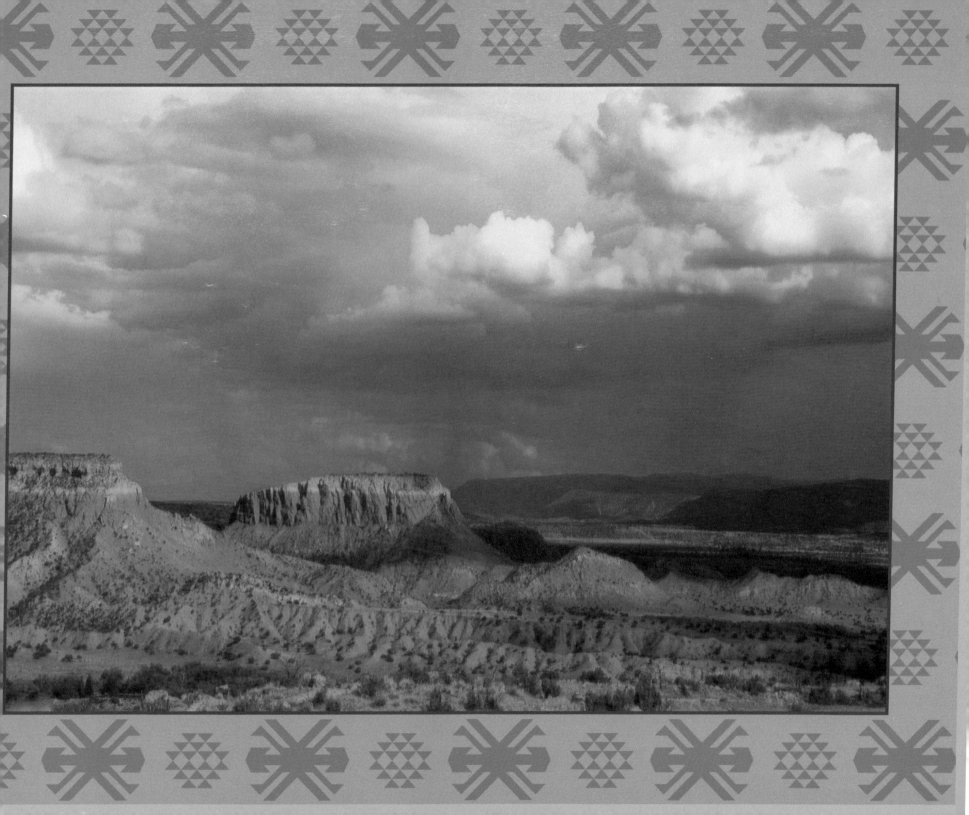

Sacred Santa Fe

Forever enchanting,
no matter the season.
However, Christmastime,
creates a whole new reason.

The city, different,
takes on a sacred glow.
With its adobe homes,
coated with snow.

Gently rounded,
in that Santa Fe way.
Casitas and ranchettes,
both sparkling and gay.

Strings of crimson peppers,
grace the vigas and beams.
A more charming vision,
will never be seen.

Smoke from the kivas,
curls into the chilly indigo sky.
Creating sweet signals,
for all who pass by.

Blue tortillas,
with chili of red and green.
When they say it is spicy,
we know what they mean.

However, she will show you,
her charming native best.
When you walk Canyon Road,
with her many guests.

Illuminarios and farolitas,
light the winding path.
As holy carolers sing,
their own private mass.

Folks that have travelled
from around the world.
No matter their origin,
both boys and girls.

Creating a world of peace,
not easy to repeat.
A heart touching happening,
worth each and every beat.

Mother Mary, the blessed virigin,
and Jesus the Christ,
hold court over this town,
on each Advent night.

There simply is no other
experience quite like this.
A place so incredibly magical,
it's difficult to resist.

Christmas in Santa Fe,
walking Canyon Road.
A memory to last forever,
a sight to behold.

Feliz Navidade,
until we meet again.
You are a lifetime gift,
my beautiful new Mexican friend!

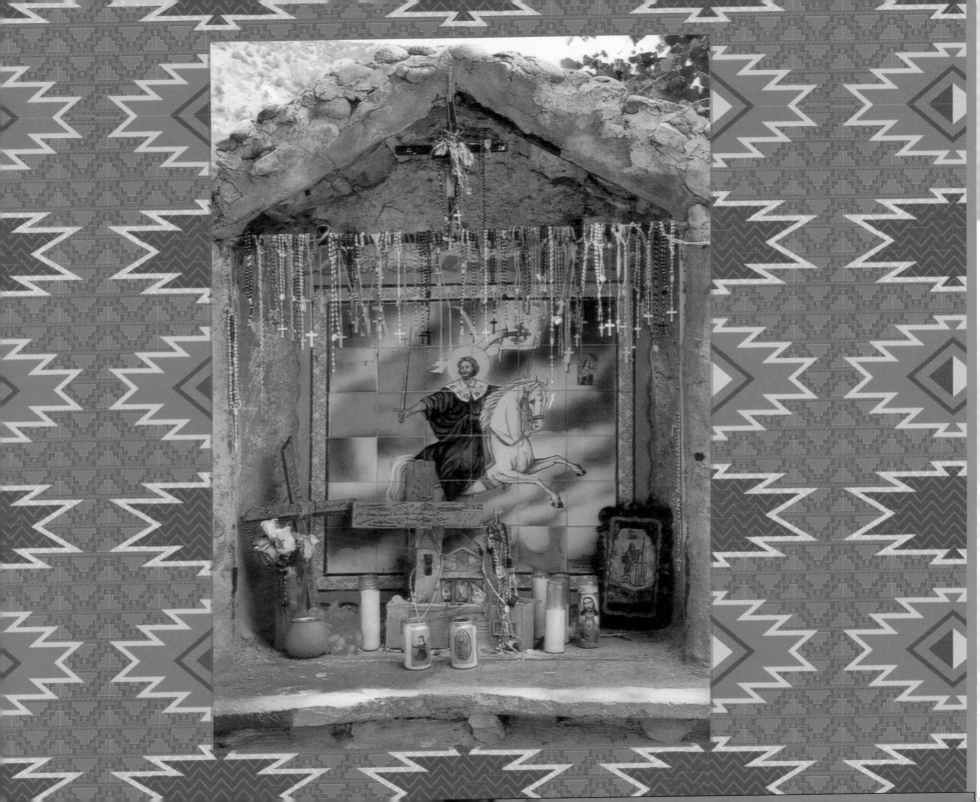

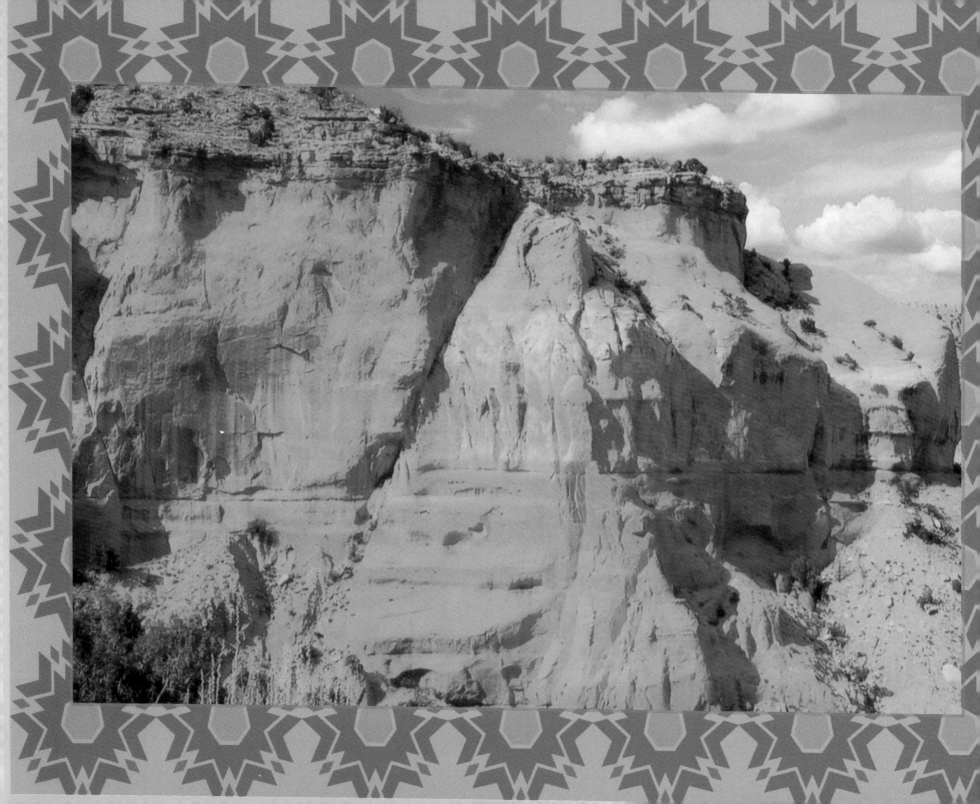

My Desert Darling

Driving thoughtlessly,
drifting along.
The desert sings
her lonely song.

With her hills of ochre,
amber and gold.
It fills the vision,
of this simple soul.

No reason to think
as I travel the land.
A wish for silence,
a solitary man.

Desperate to quieten,
my rambling mind.
Observing her beauty,
in my own peaceful time.

The soft sumptuous forms,
of her exotic sand,
calls to my senses,
in this tribal land.

No reason to question,
where the mind may go.
Just simply embrace it,
and feel the glow.

Thoughts of life,
force their way in.
I do not wish,
this reverie to end.

So, I shut out reality,
for one more hour.
Using each moment
to savor and devour.

Driving through the desert,
my savior of the mind.
Wishing to embrace you,
just one more time.

Being a being,
with all the flaws.
Thanking my God,
for this sacred pause.

Forever my lover,
eternally there.
You give to my being,
this time to share…

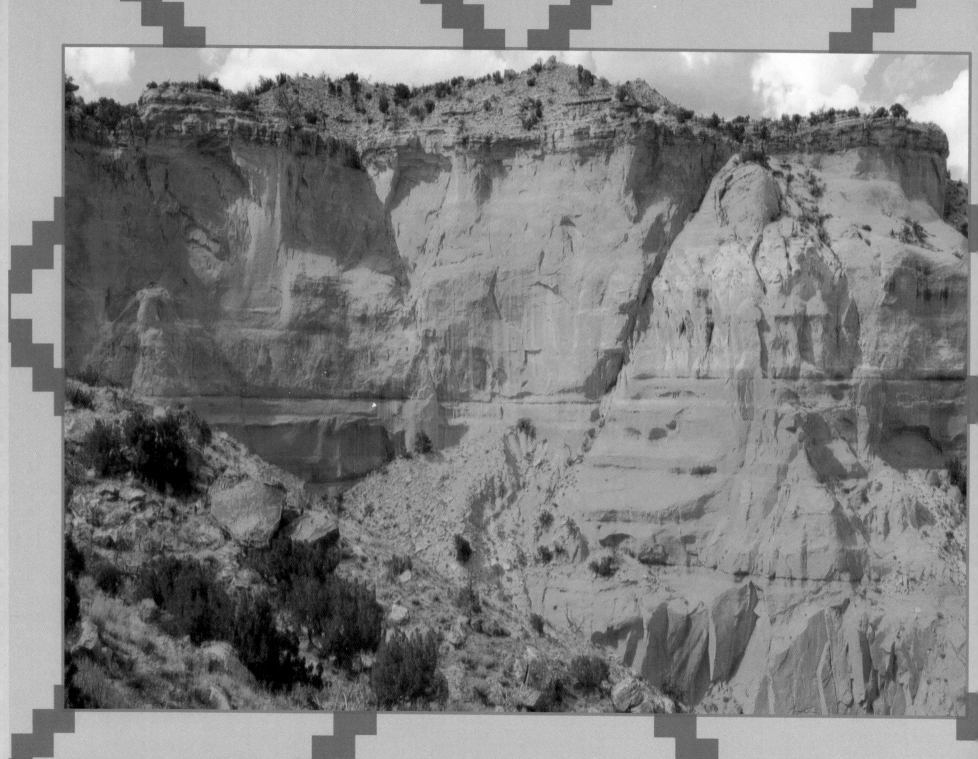

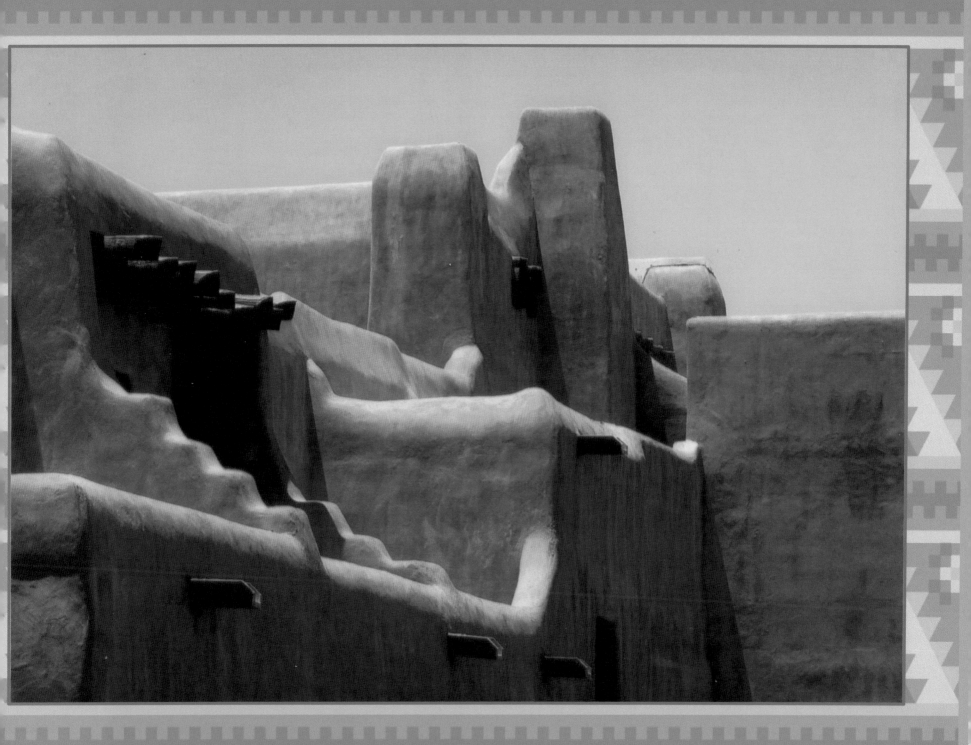

Santa Fe Dreamin'

Taking a break,
up New Mexico way.
Headed on out,
to our beloved Santa Fe.

Sacred respite,
visual delight.
Sunset heaven,
starry, starry night.

Adobe haven,
art abounds.
Another world,
built on ancient grounds.

Turquoise hues,
illuminate the sky.
Amethyst clouds,
as heaven rolls by.

A land of enchantment,
its magic persists.
Captivates our soul,
a reason to exist.

A culture of old,
found searching for gold.
A treasure found there,
to have and to hold.

A country unique,
in oh, so many ways.
Cool mountain breezes,
on warm summer days.

It is my land,
for I hear its Spirit call.
Completely at peace,
content with it all.

This city, different,
where all blends in.
Destination of choice,
surrounded by friends.

Santa Fe dreams,
I've had me a few.
It calls to me daily,
to start life anew.

To live life in peace,
with the world put aside.
Taking each day slow and easy,
going along for the ride…

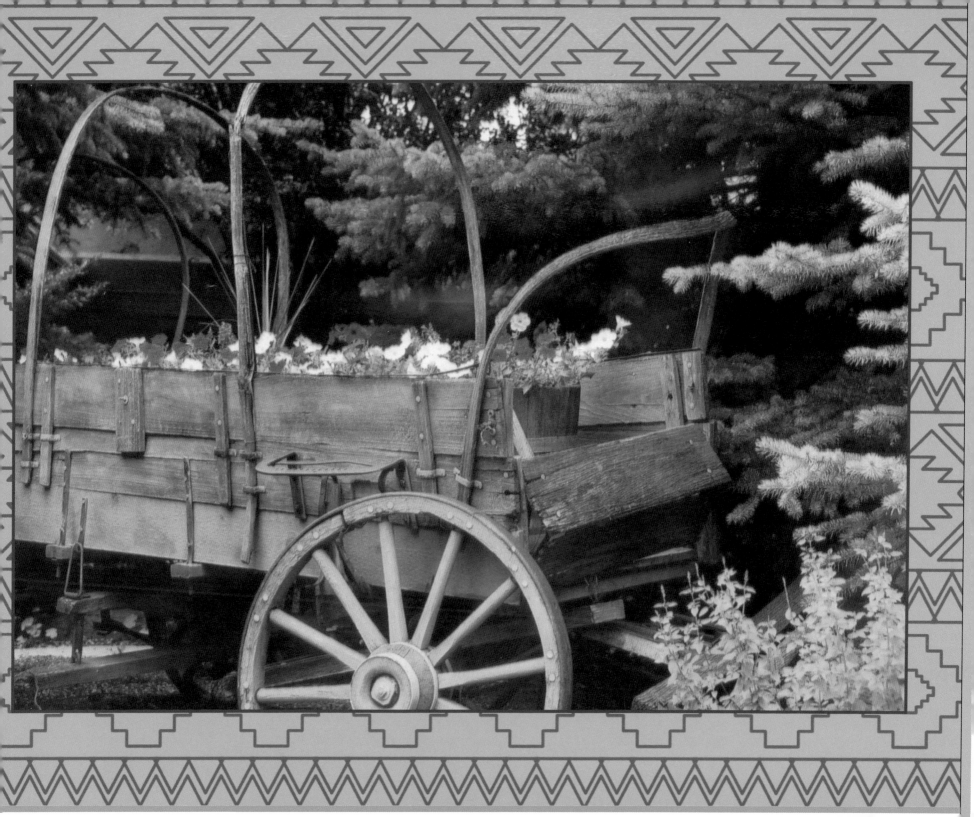

Morning Light

The pure crystal light,
from the Dresden sky.
A magician's moment,
A Santa Fe high.

Casting a spell,
upon my adobe castle.
Creating a golden world,
quite void of all hassle.

The shadows so distinct,
as its image creator.
A vision so stunning,
a mood elevator.

The morning is still,
the leaves barely shudder.
My life at this moment,
is truly like no other.

I praise my God
for the glory I see.
I praise the One
who let me be.

Gave me the chance
to live life on high.
Lay down in the sand,
under the New Mexico sky…

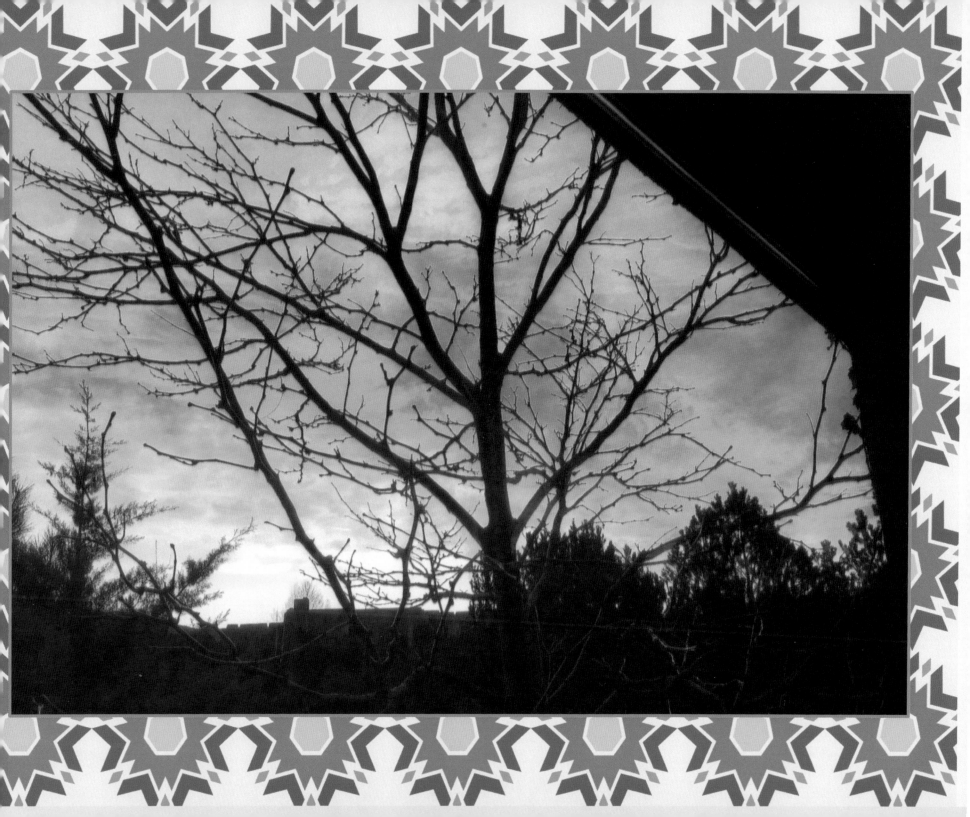

Enchanted Land

Rolling hills,
mountainous views.
Heavenly moments,
creating life anew.

Fairy tale clouds,
that touch the earth.
Acres of terrain,
with terra cotta dirt.

Skies of sapphire,
with an amethyst glow.
Sprinkled magically,
with a shower of snow.

Homes of the earth
and simple mud.
Shaped and molded
by men who could.

Sunset and sunrises,
that alter the mind.
Each and every day,
a one-of-a-kind.

An original culture,
that walked this land.
Indians and Mexicans,
under Spain's command.

Bold and spicy,
unique cuisine.
Not for the timid,
nor in between.

The city, different,
in the land of enchantment.
Not one personality,
is taken for granted.

Artistic talent,
flourishes and blooms.
A vision of originality,
with nothing assumed.

Though the population
numbers quite few,
originality is
What they do.

Opera and theater,
markets galore.
Antiques and jewelry,
and so much more.

Nowhere like it,
This place that I roam.
Always and forever,
my Santa Fe home.

Desert World

What if the desert
was the universe?
Each grain of sand
a soul on earth.

Each tiny granule
held a man.
Just another concept
about God's plan.

Where is the molecule
that tells you apart?
Could it possibly be,
a matter of the heart.

Millions of beings
crowd the earth.
Even as some
return to the dirt.

A vastness of life
making up one.
Rolling and rippling
under the noon day sun.

To the common eye
they appear the same.
However, not one single human
is easy to explain.

We eagerly await
one drop of rain.
Waiting for God
to quietly explain.

Looking for reasons
why we exist.
A humble inquiry
of why we persist.

Stretching for miles,
this phenomenon called man,
or, are we just another
pile of sand.

Just a folly
like a castle on the beach.
Looking for the lessons
it will ultimately teach.

Desert dreaming,
or, is it a mirage?
Just another joke
created by God.

I shall fill by pail
with this golden stuff.
Thinking that this poem
has gone quite far enough…

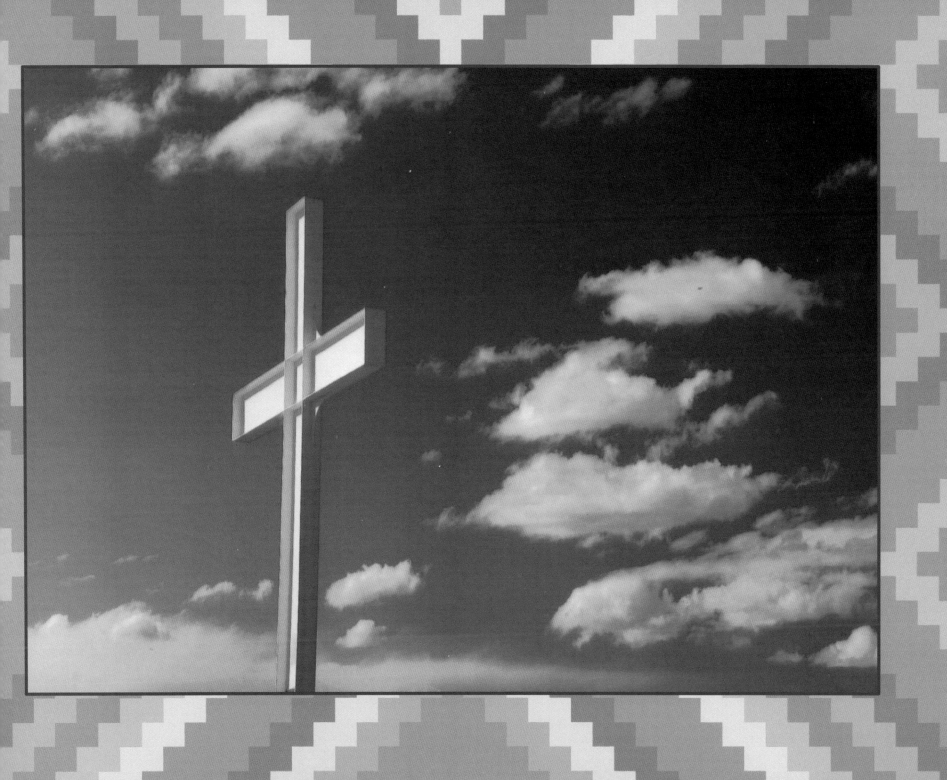

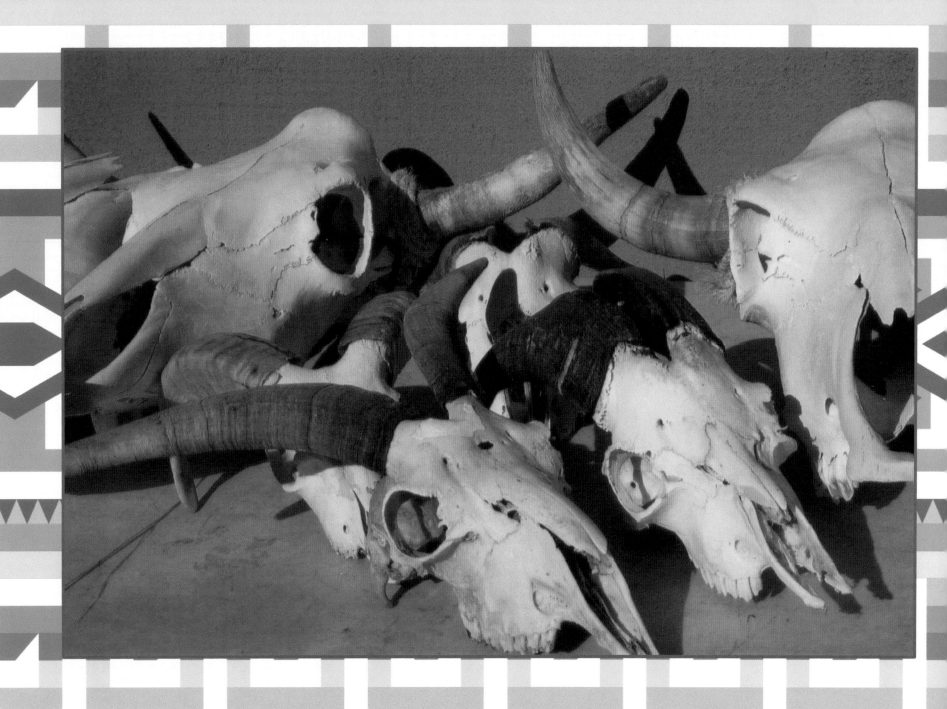

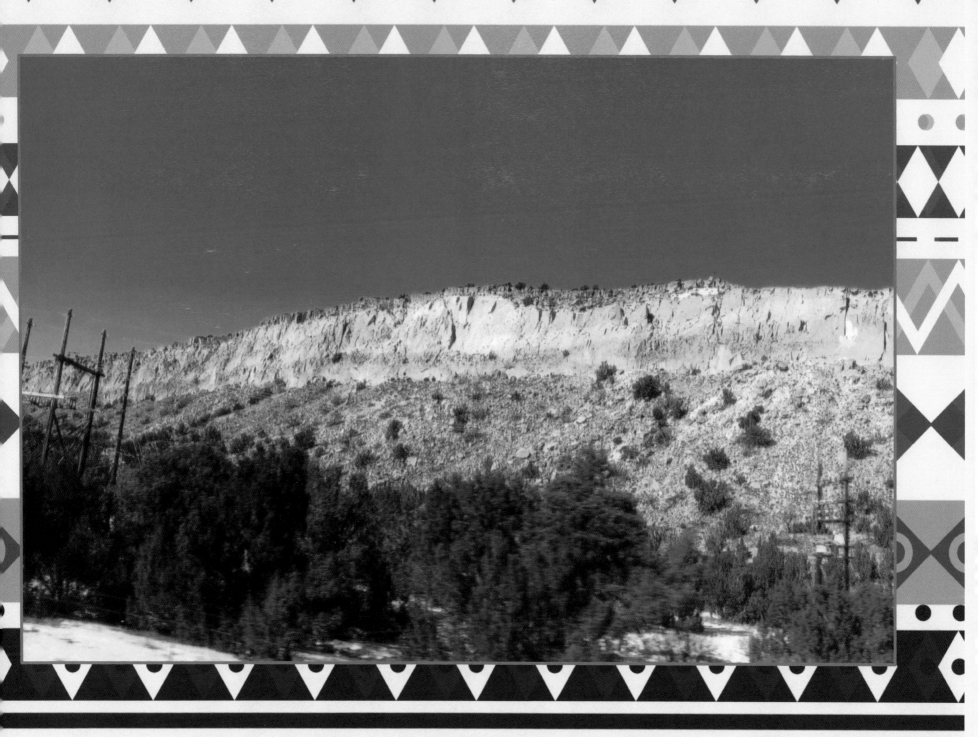

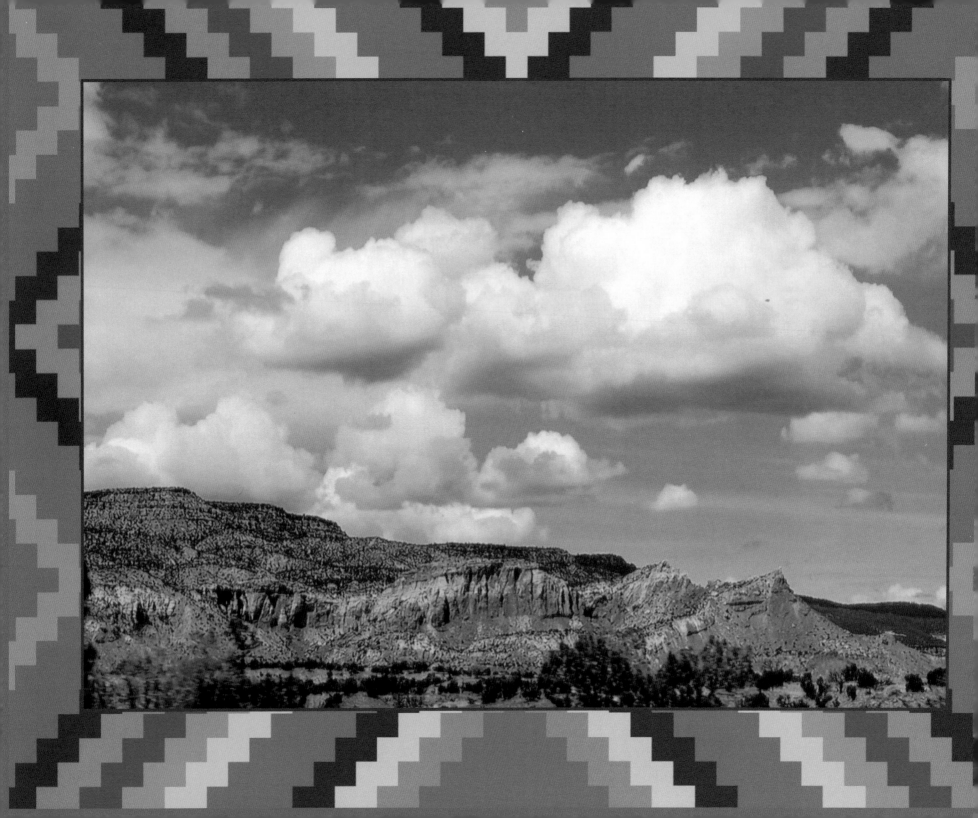

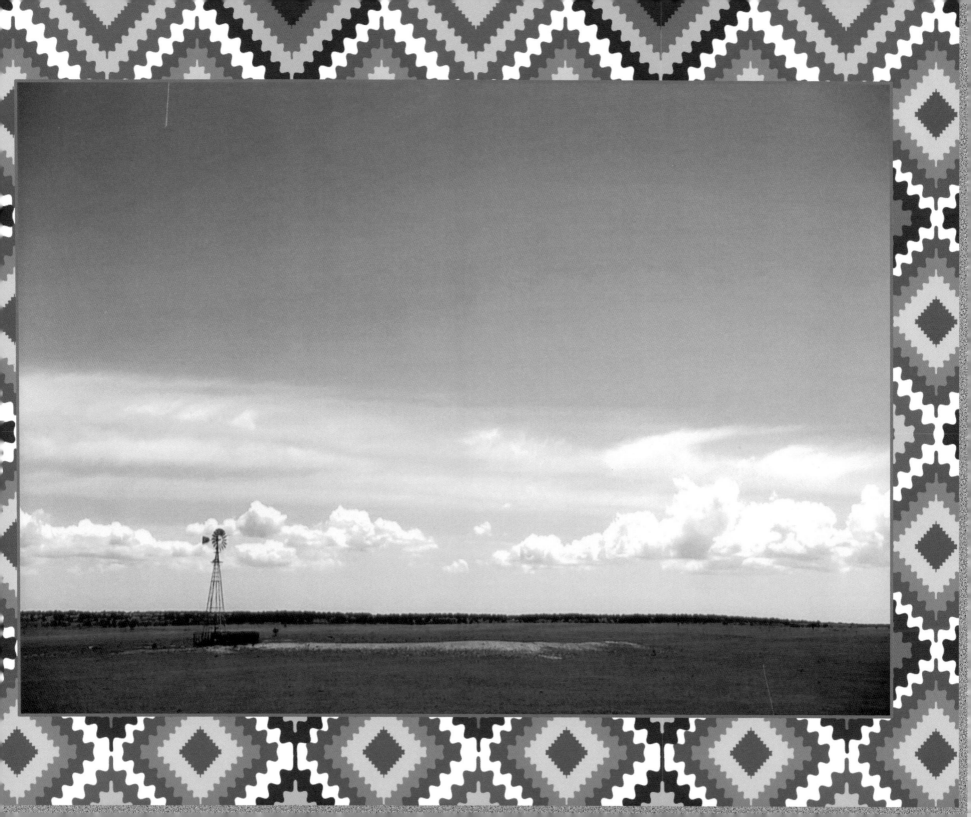

Forever Enchanted

That aura of enchantment
always greets me there.
As I exit the highway,
to this city so rare.

It calls to me sweetly,
with its beauty so fair.
Guiding me as forever,
on a wing and a prayer.

With heavens so clear
they blind the eye.
I return to the city different,
with her turquoise blue skies.

Endless landscapes,
with pale golden sand.
Artistically rendered
by many a man.

Indians and Mexicans,
sisters and brothers.
Simply an appeal
unlike any other.

Year after year,
we faithfully return.
A longing for her magic,
and secrets to learn.

Sunsets and the dawn,
of which we never tire.
These moments of reverence
that continue to inspire.

Snow-capped peaks,
verdant and grand.
As I quietly observe them,
one very happy man.

A mecca for the talented artist,
Many, world renowned.
With travel through many a gallery,
in this sleepy little town.

Santa Fe Oh Santa Fe,
where I long to reside.
Knowing I will be blessed,
by her mystery and her pride…

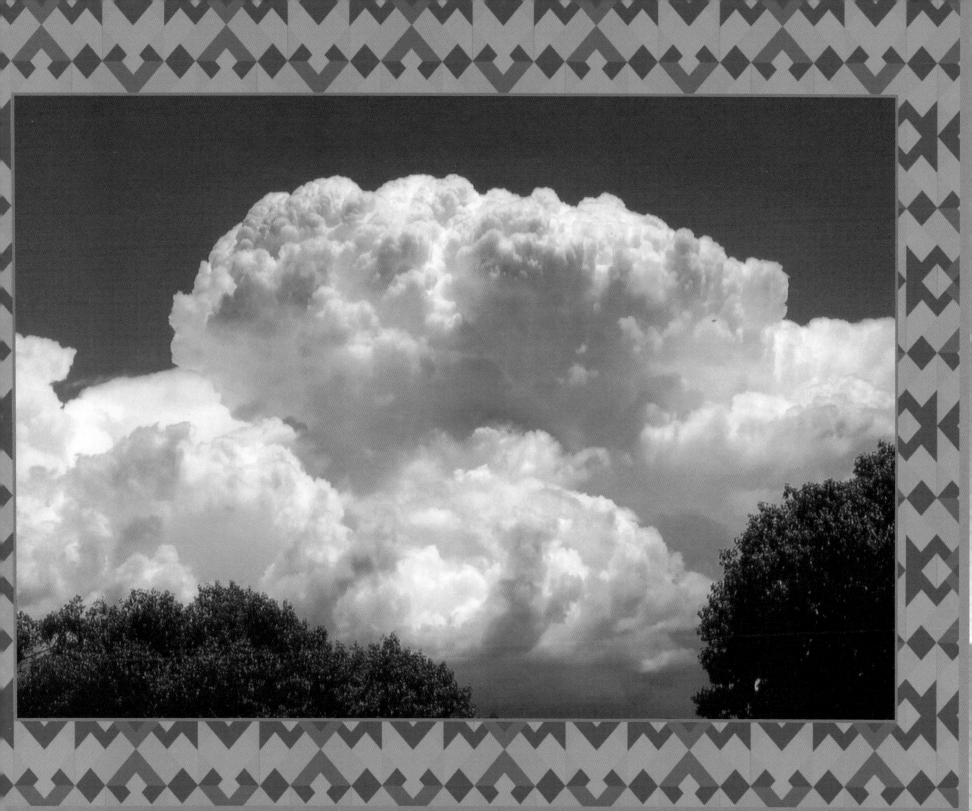

Ashes And Memories

Through the mountains,
and snow fed streams,
we spread your ashes,
a wished-for dream.

We said quiet prayers,
to the deer and the dove,
and scattered your soul,
with tearful love.

Beneath the pines,
and near the waterfall,
we let you drift,
now a memory to us all.

Placed on altars,
and in sacred ground.
Places of privacy,
not soon to be found.

Seated on a bench,
in the age-old plaza,
we lovingly release
the dust of your body.

We've searched through this mecca,
for where you might rest,
and hopefully selected
the very, very best.

Places to enjoy,
a beautiful, peaceful end.
Something you longed for,
forever my friend.

A gentle breeze
has carried you away.
We shall think of you always,
each and every day.

Goodbye my darling.
You loved the very best.
I now bid you farewell,
in the paradise where you rest…

This is dedicated to our dear and
precious friend, Rusty Beck.
She is at last where she longed to be.

Sunset By God

Amber clouds,
apricot skies.
Cerulean shadows,
a desert high.

Sun's farewell glowing,
as the day meets its end.
A sight of such splendor,
a spiritual blend.

Growing more magical
as the seconds pass by.
Awed by this miracle,
a painting in the sky.

God lifts his finger
and punctuates our lives.
The end of twelve hours,
the beginning of night.

Each work an original,
never before seen.
Created just for us,
grateful human beings.

I linger in the light,
of those fading rays.
Ever so grateful
that I came this way.

Blessed by these moments,
seen only by me.
A gift of such magnitude,
this perfect spot to be.

A grateful "Good Evening",
a sweet "Nighty Night".
This shall always remain,
exquisite in my sight.

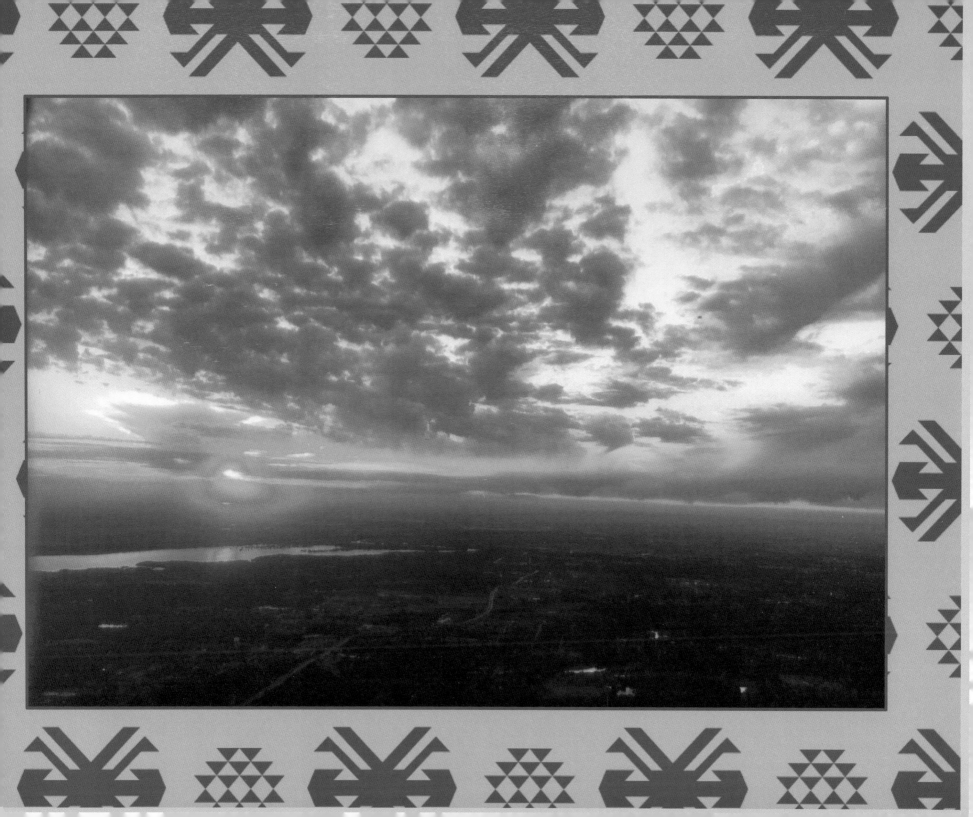

Sittin' On The Portal

I'm just sittin' and watchin'
that old Santa Fe sun,
Inching its way up slowly,
on the amber horizon.

I ain't givin' no advice,
and no opinions at all.
Cuz I'm just sittin' and rockin'
on my big old portal.

You ain't my Facebook friend,
and you're shore outta luck,
cuz my little old IPad
got runt over by a 4 wheel truck!

And I'm just sittin' and dreamin',
not worried at all.
Right out here,
on my little old portal.

And I'll kick your bony ass,
if you send me a tweet.
Cuz what I have to say 'bout you,
is short and not so sweet.

And I'm just sittin' and rockin',
and doing very little thinkin'.
In fact I'm just contemplatin'
doin' a little mo drinkin'.

Now my flat screen TV,
fell off the wall.
I gave it a nice funeral,
UVerse, Dish, Direct and all.

So, as the sun slowly sets,
I raise my Cuervo from where I sit,
and make a little toast,
to my old dawg named "Shit".

Cuz you know what I discovered,
when I named that rowdy pup?
That was just how I felt,
about that scruffy little mutt.

So, I'm just sittin' and drinkin;
And not giviin' a flit.
Cuz me and ol' Shit
think this is pretty much IT!

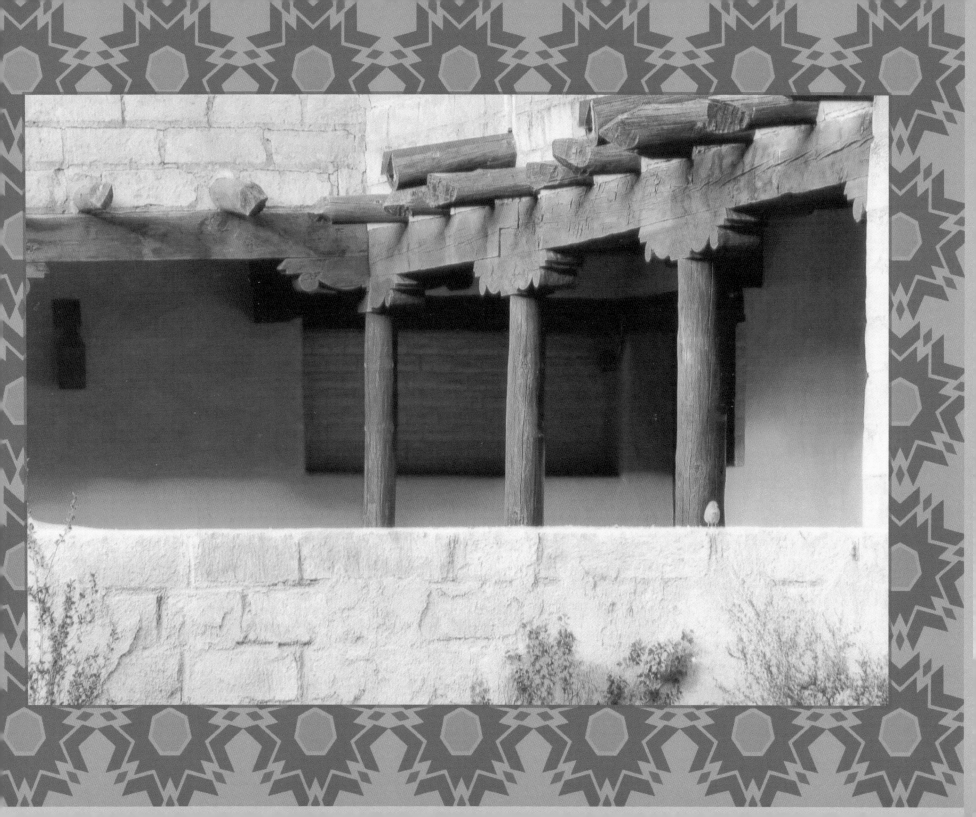

Sun Setting

You send me this miracle,
each and every day.
As evening descends,
and the sun goes its way.

A breathtaking scene,
of clouds and light.
A magical moment,
to inspire my life.

Often the rays,
are amethyst and gold.
Never quite knowing,
how this event will unfold.

Heavenly clouds,
like cream on a cone.
Inwardly glowing,
from a source unknown.

Changing rapidly,
before my eyes.
Taking precious photos,
before its demise.

Not one setting,
is ever quite the same.
Teasing me daily,
God's favorite game.

Not once do I tire,
come what may.
Each the perfect ending,
of another splendid day.

Never do I remember,
sunsets as such.
For it seems they've improved,
ever so much.

Watching old Sol's descent,
I observe and pray once more.
A sight I shall always treasure,
love, cherish and adore.

God's sweet period,
punctuating my day.
A gift most precious,
in each and every way.

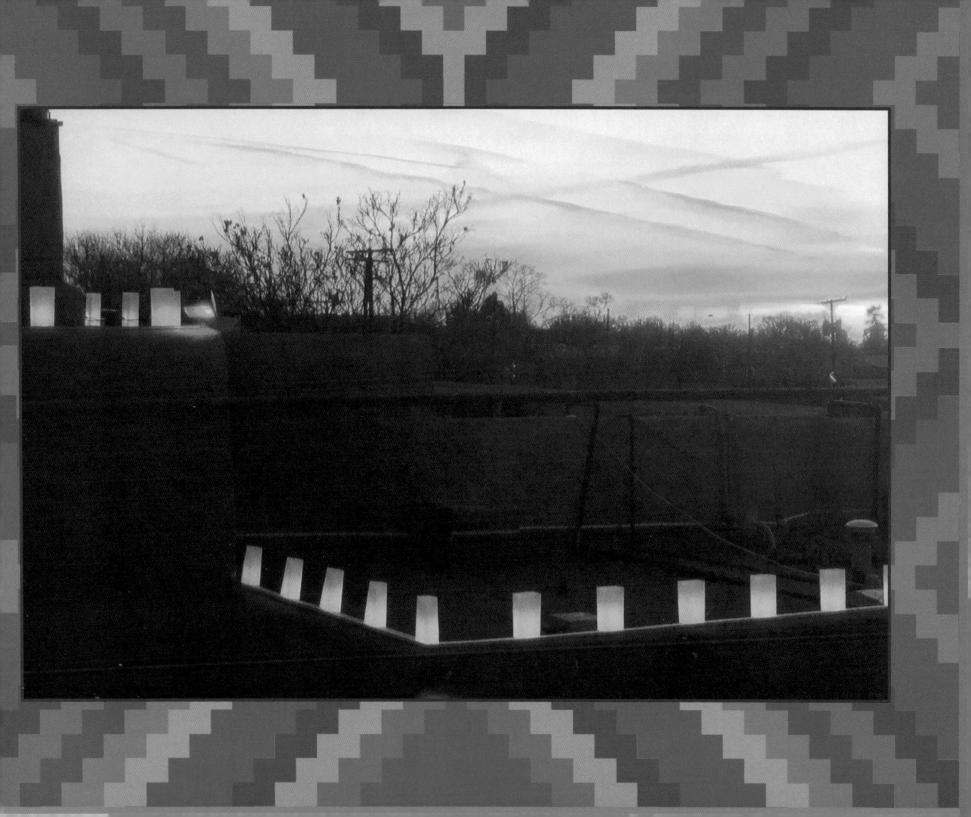

Trees Of Santa Fe

Elephant textured bark,
with their color steely gray.
Reaching out to touch the sky,
of what age, no one can say.

The cottonwood and aspen,
bringing their soft symphony.
With silver green leaves aflutter,
in the gentle New Mexican breeze.

The pine stands quite regal,
in its uniform of evergreen.
Whispering in the wind,
never revealing what it's seen…

The trees bearing fruit,
peach, apricot, apple and pear.
Bringing flowers to sweet Spring,
with a promise to bear.

Gnarled yet graceful,
an enigma quite rare.
They welcome each honey bee,
with the fruit they gladly bare.

Though few in their number,
very rare to be seen.
They bring to this burnt desert,
their cool and verdant green.

A symbol of fortitude,
no matter the circumstance.
A quiet and beautiful Life can exist
where there is very little chance.

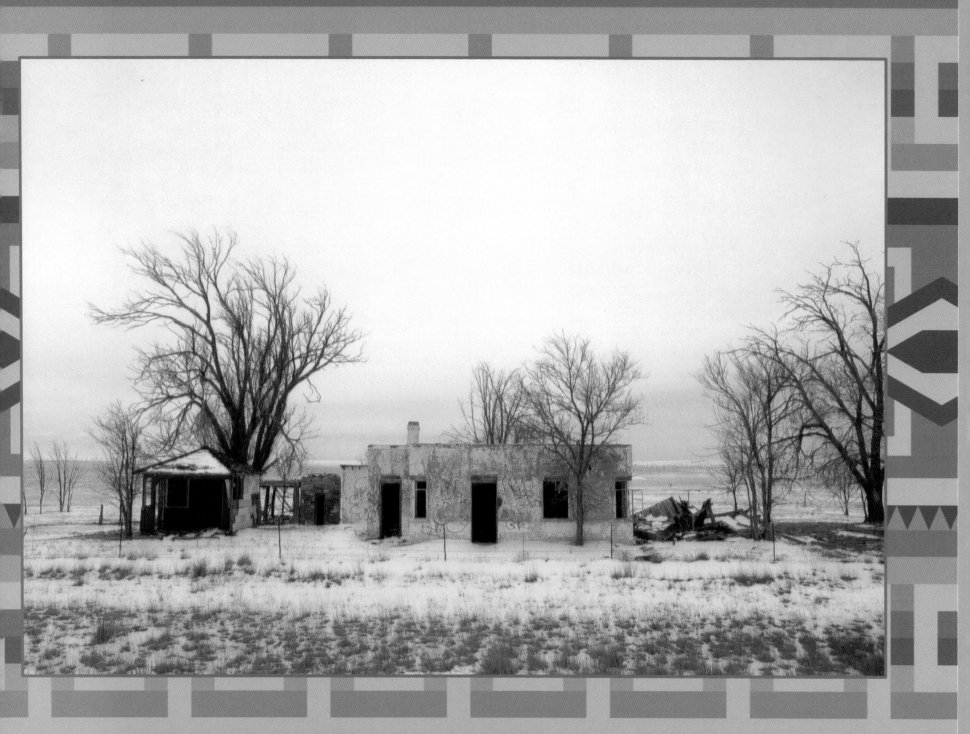

Holy Ghost

Billowing clouds,
over windswept plains.
Claps of thunder,
an ovation for rain.

Desert buttes,
where canyons run deep.
A desolate life,
that Georgia did keep.

Adobe dwellings,
dot the land.
Acres and acres,
covered with sand.

A way of life,
desired by so few.
The clear possibility,
you might get to know you.

Lonely cattle,
graze the land.
Ways of surviving,
a chore for man.

A solitary creek,
wanders through the scene.
A source of water,
with its limited means.

Hardy creatures,
fight to exist.
Rodents and reptiles,
with a will that persists.

And yet it's beauty,
cannot be denied.
Taking away one's breath,
under those turquoise skies.

God's sly gift,
with its magical appeal.
Often so inspiring,
with a touch of the surreal.

Artists wander the terrain,
a treasure to their brush.
Photographers use their lens,
with an adrenaline rush.

She lies there in her magnificence,
calling to your mind.
Who will be the admirer,
that returns time after time.

A rare piece of earth,
that holds her secrets dear.
One I shall return to,
every time I am near.

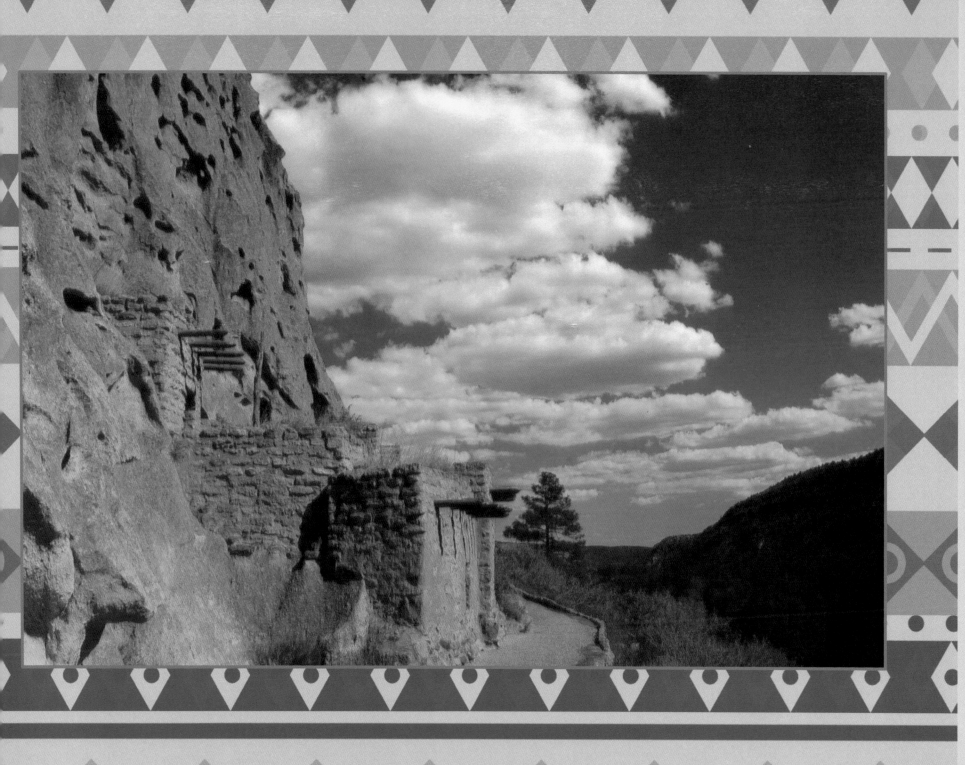

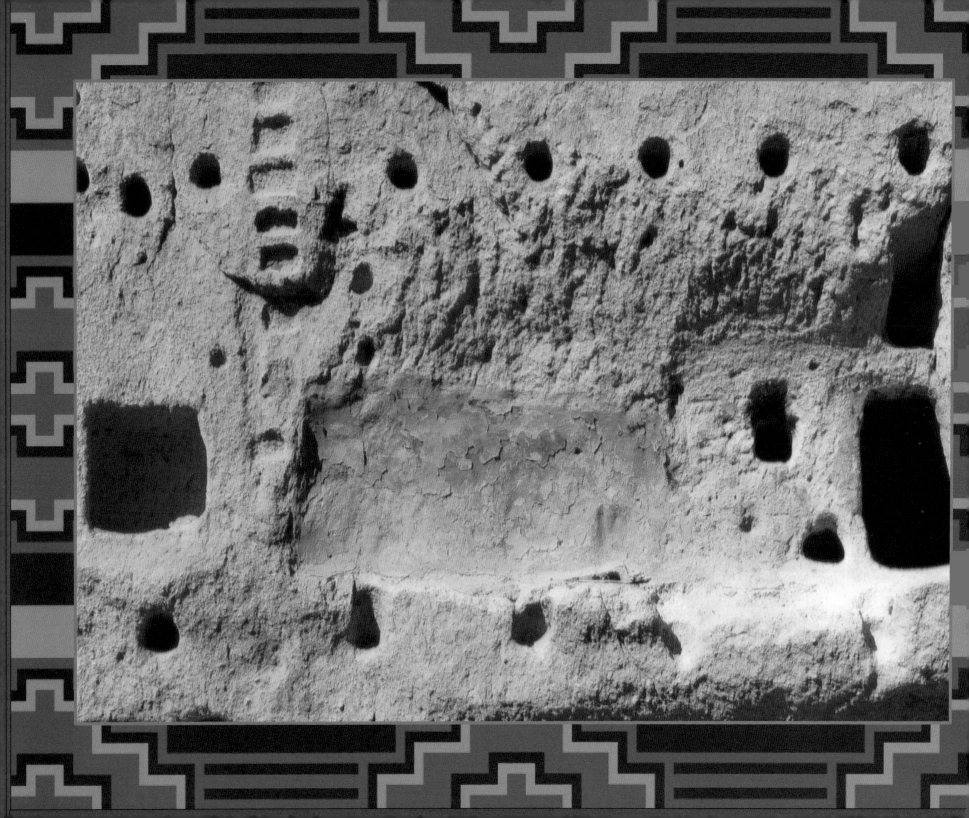

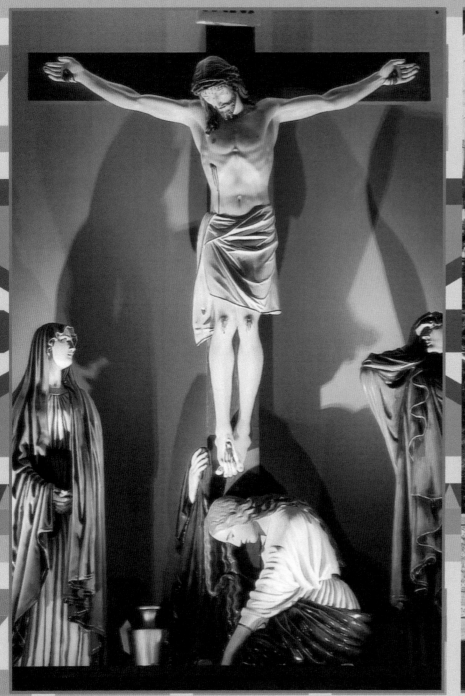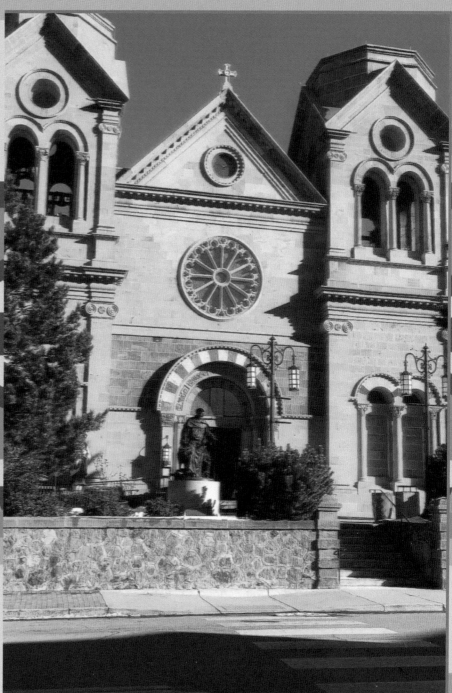

Cathedral

Entering the cathedral,
of holiness and grace.
I honor and respect
this most sacred space.

I feel its history,
coursing through my veins.
As when God and the pope,
were considered one and the same.

Saints and angels
cover the ceiling up above.
A challenge for the artists,
done with devotion and love.

Beams of diffused light,
stream through the stained glass.
A more God-like experience,
shall never come to pass.

The blessed scene touches me,
deep within.
As I think of the prayers whispered,
since time began.

Though it is not my faith,
nor is it my belief.
However, the years of history
are profound and unique.

It's age-old philosophy
is not of my concern.
With its stories of hell,
where the sinners shall burn.

I take in its essence,
that brings solitude and peace.
Finding that special place,
that I've longed to reach.

Kneeling at my pew,
where many have before.
I think about my faith,
and so much more.

Quietly as I exit,
this glorious holy place.
I know somehow in my heart,
I have met God face to face.

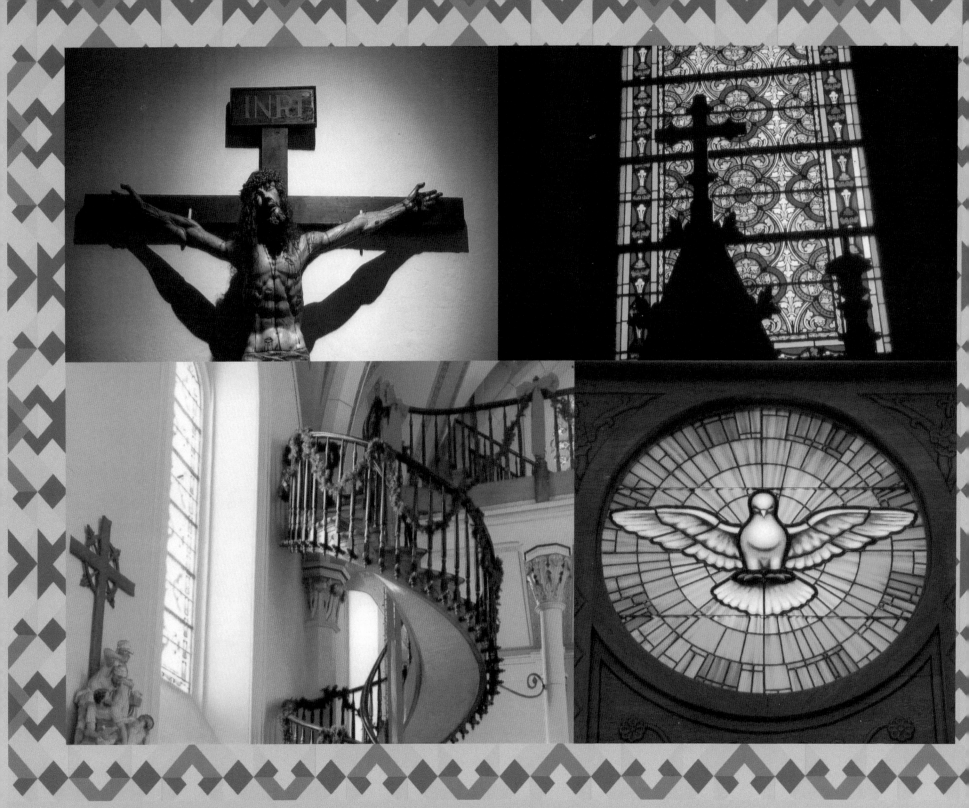

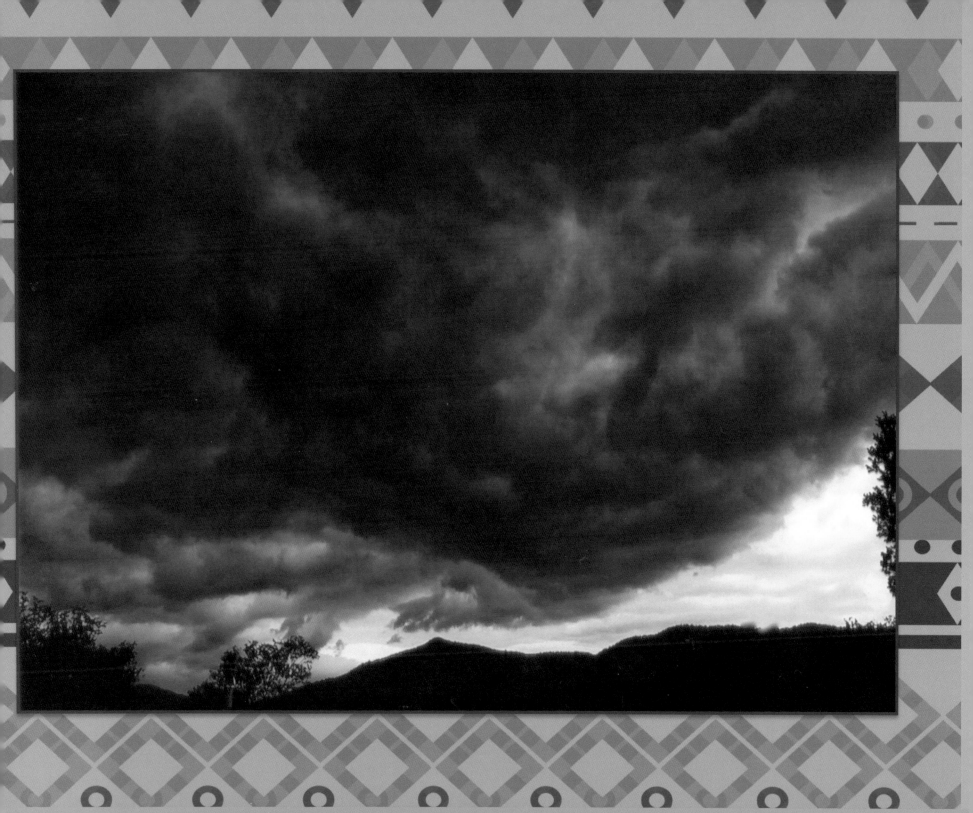

County Clerk

Joy abounds,
in this small quaint town.
Clerks with smiles,
happiness all around.

Authentic welcomes,
no doubt of that.
Issuing their papers,
quite matter of fact.

A time unexpected,
in a sense most surreal.
This privilege awarded,
after years of repeals.

Couples with histories,
dating 30 and 40 years.
At last to be legal,
a celebration of precious tears.

Standing at last,
for the world to see.
With rights finally honored,
a century of pleas.

The judge in his robes,
performing his rights.
Truly a miracle,
for which many did fight.

And yet, as stated,
this rare situation.
Being treated equal,
with no reservations.

A wish never considered,
a time never dreamed.
Difficult to realize,
this unrealistic scene.

A grateful union,
of two loving souls.
Thank God it was realized,
before we grew old.

In the land of enchantment,
where miracles never cease.
Two humans bond their love,
and the whole world is pleased…

Upon our Santa Fe wedding, March 13, 2014

Deconstructed

Life in the "City Different",
where all is abandoned and free.
Where rules and regulations,
are of very little need.

Where most all of society,
doesn't really give a damn.
And I can be precisely,
who I think I am.

Time is of minor importance,
and appointments are of little use.
No reason to call them rude,
or feel like you're abused.

Perhaps even manana,
we will do what should be done.
Or perhaps it will never happen,
because it just isn't any fun.

We've become so accustomed,
to everything perfect and neat.
With our hedges shaped relentlessly,
and no holes in the street.

Tedious anonymous houses,
all in an OCD row.
Unless they know your number,
your guest may never show.

Mansions of grandeur,
with those same boring yards.
One looking like the other,
on yet another manicured boulevard.

One of those little thoughts,
that never crossed our mind.
One that has become so rote,
it has left us somewhat blind.

But, back to the enchanted land,
where nothing seems trimmed at all.
It appears that the local gardeners,
were having a free for all.

Perhaps the only trait,
that might give them away.
Is that all of the adobe structures,
must be built the same way.

Just a little thought,
brought to me by a friend.
Who knows how I will digest it,
when I take it all in.

Life in an orderly fashion,
a choice that is ours to make.
Rather to live our lives authentically,
or spend it mostly as a fake…

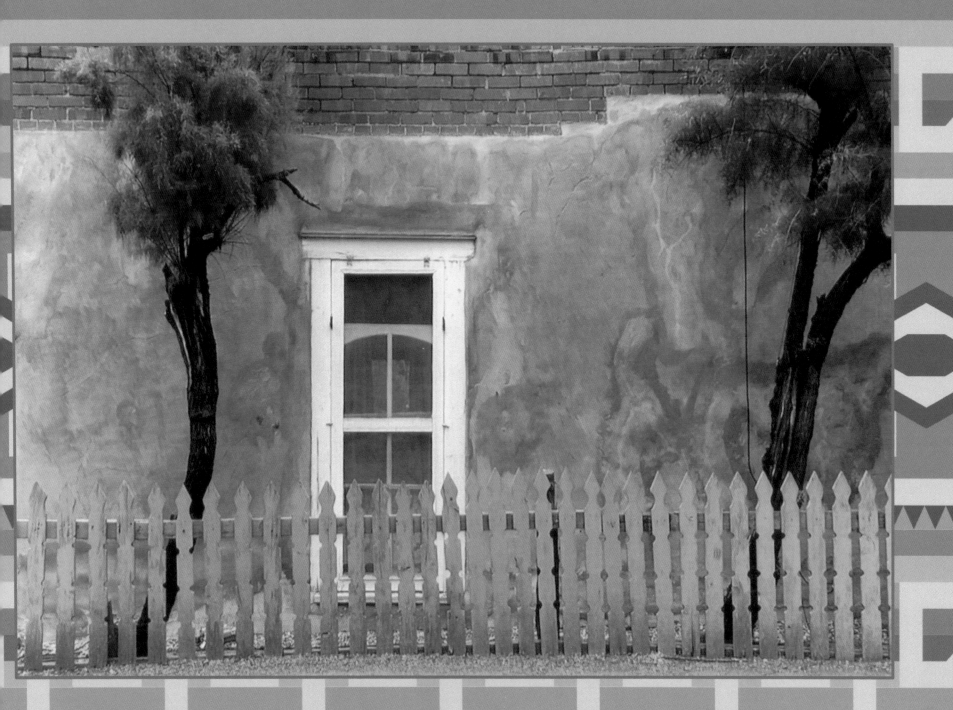

Santa Fe On My Mind

I head out on the highway,
to Highway 287,
Determined to reach Nirvana,
and that place I call heaven.

Steering my speedy vehicle,
headed up to this magical land.
Thinking of adobe and margaritas,
I'm one happy man.

Turning on the radio,
we rock on down the road.
Mind focused on red chili,
getting into the southwestern mode.

Flat land surrounds us,
with a few horses and cows.
While in my heart of hearts,
I wish I were there right now.

The sun has risen,
and the hours have passed.
We stop in occasionally,
for a coke and some gas.

We lunch in a diner,
like in a foreign land.
With farmers and merchants,
and a few ranch hands.

Back on the interstate,
determined to cover some miles,
We sit back and relax,
with a satisfied smile.

Midway there,
we pull into a Motel Six.
Time to lay our heads down,
and get our nightly fix.

Awake at dawn,
with tortillas on our mind,
We jump back into my auto,
to head out one last time.

Six hours and counting
when the terrain begins to change.
Knowing in a short while,
we will see the mountain range.

The Land of Enchantment,
a most appropriate name.
Hills of golden sand,
and very little rain.

Welcome to the "City Different",
we are happy to return.
Knowing every single street,
and each and every turn.

Happy to be back home,
at least for a day or two.
It is one of our happiest times,
no matter what we do.

Sacred and mystical,
sunsets are their very best.
It is my soul's goal,
to come here for my final rest…

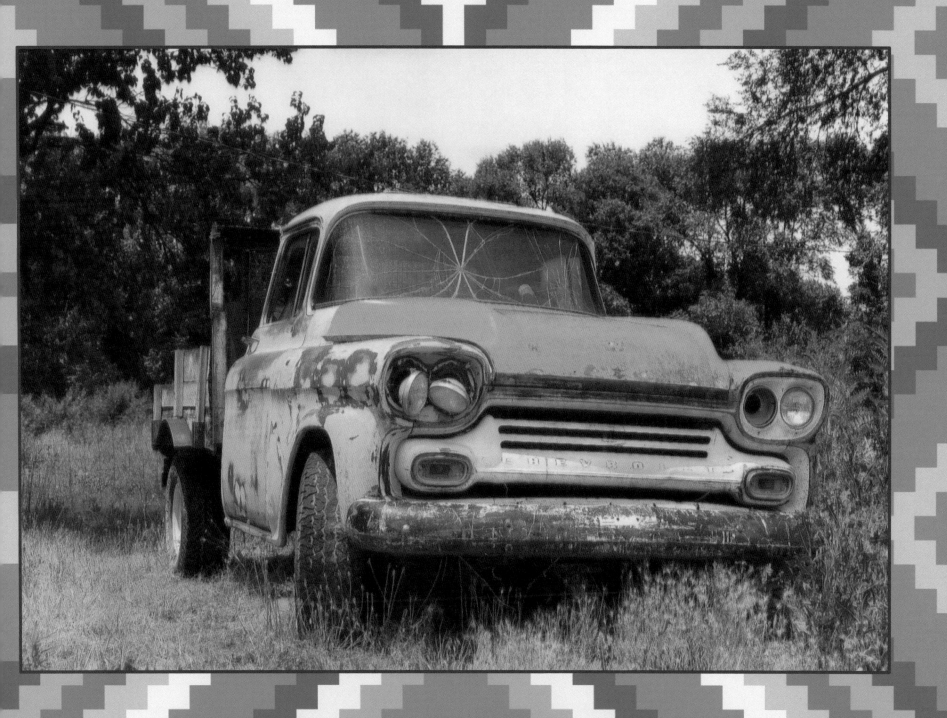

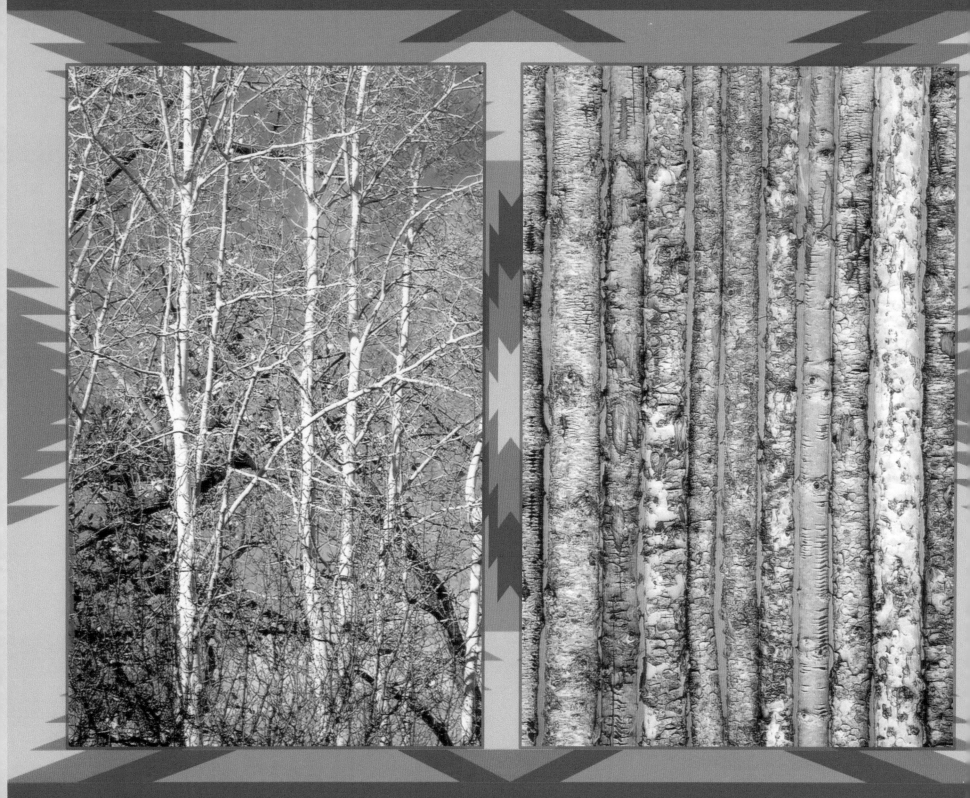

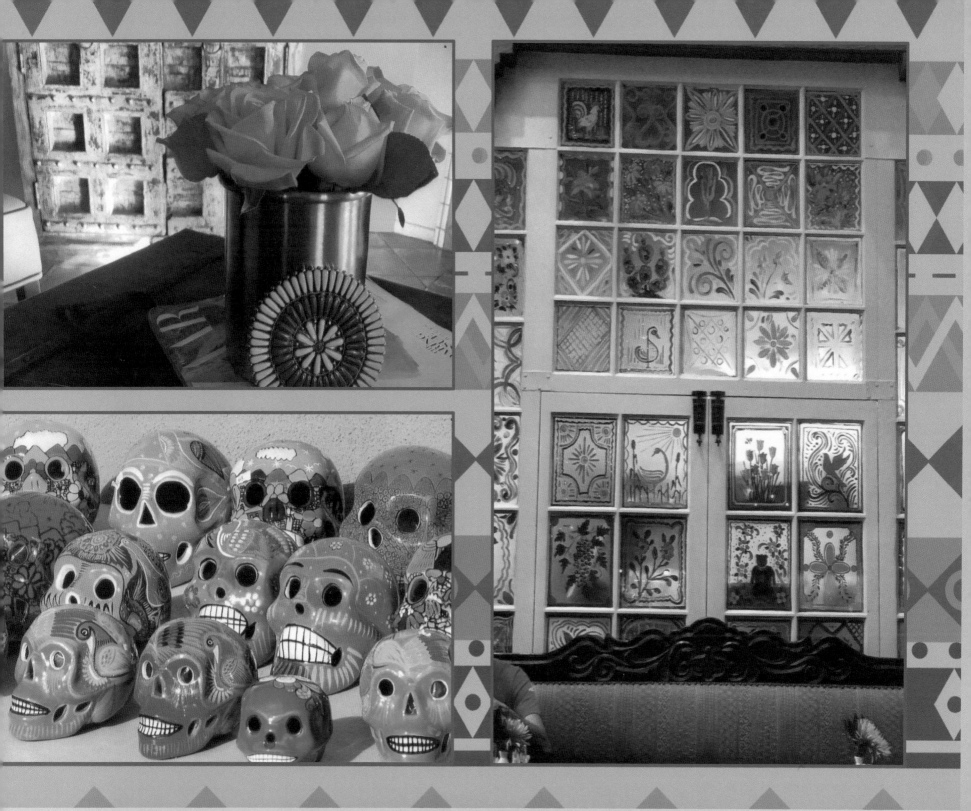

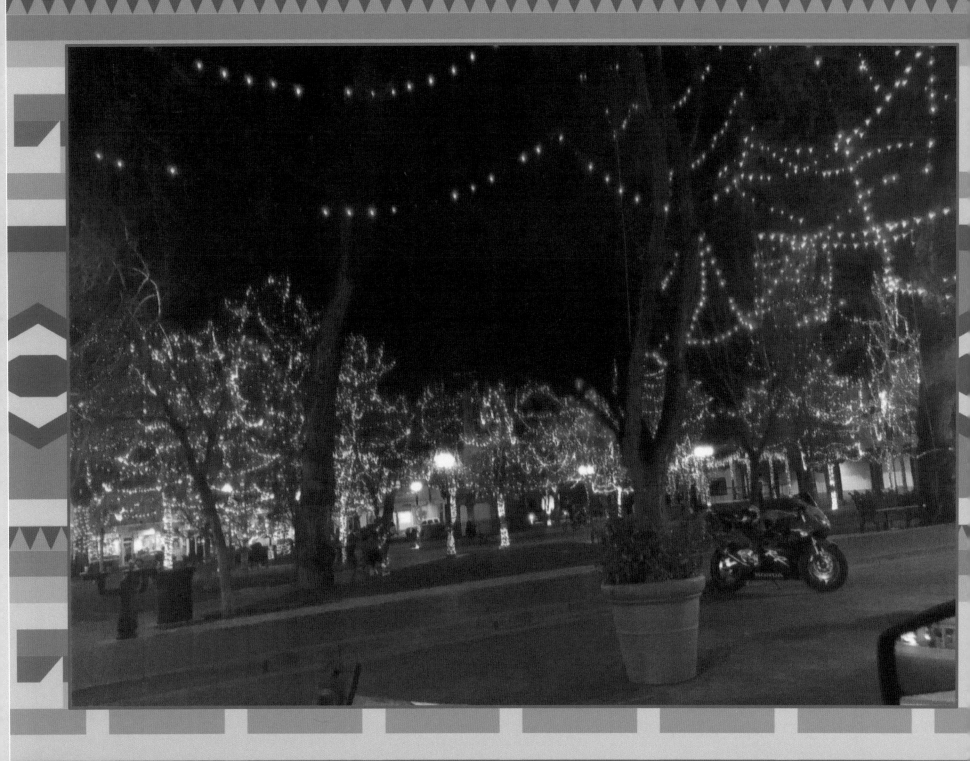

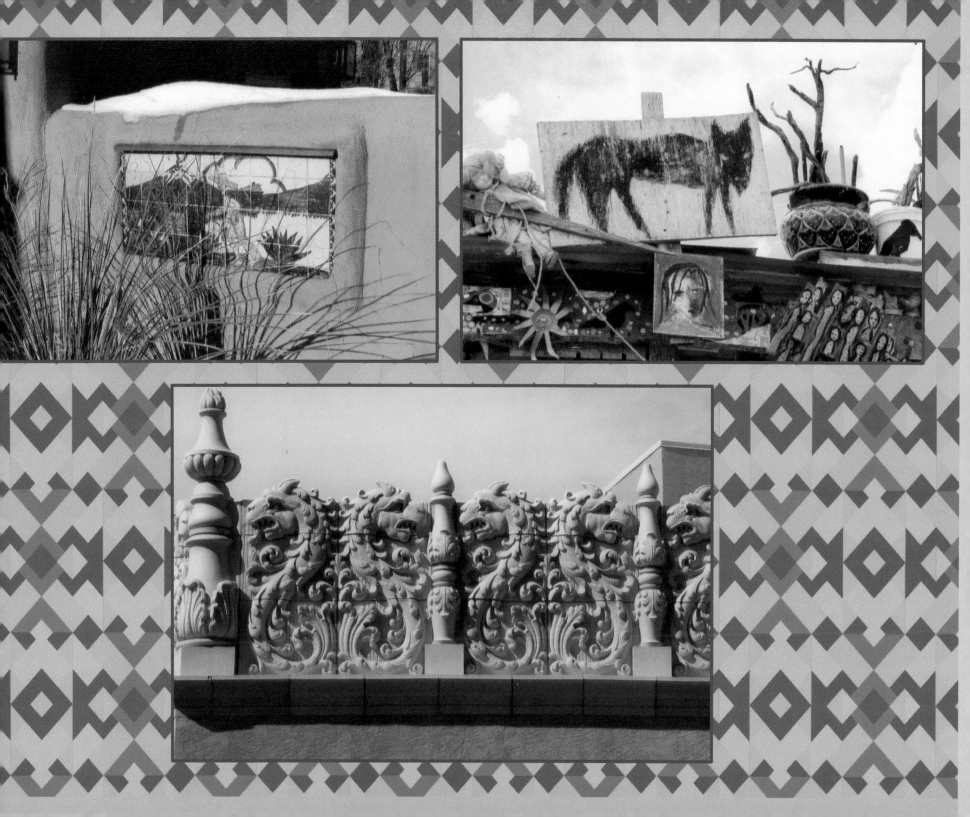

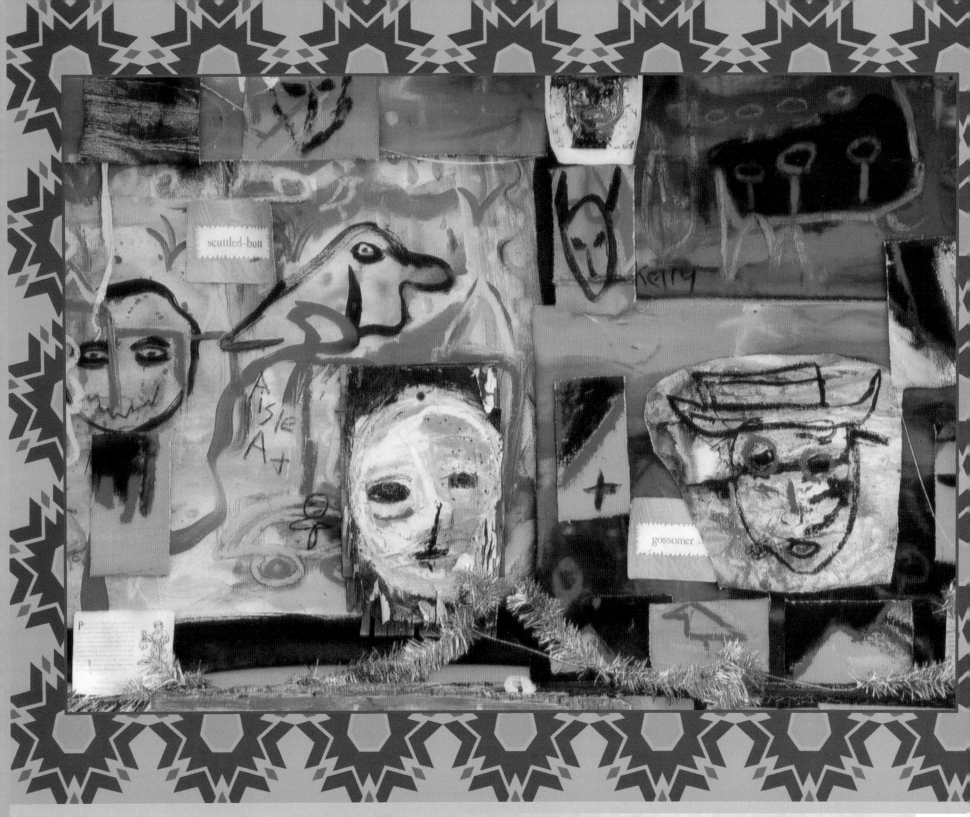

Stephen Daingerfield Dunn is a decades-long lover of Santa Fe and its people, having cherished friends and favorite places there that he returns to enthusiastically and frequently.

A resident of Dallas, Texas, Stephen is an award-winning interior designer with over 30 years experience in the design industry. He has also had an extensive career as a noted hairdresser and owner of two of the most exclusive beauty salons in Dallas, Texas. Stephen is owner of the decorative window furnishings company Le Corniche, and a one-of-a-kind pillow firm called Beauregarde.

Stephen has been honored by DHome magazine and the Dallas Design Center as one of city's best designers for 12 consecutive years. His homes have been featured in publications nation-wide, and his work cited as "…the most interesting house in the Metroplex".

Stephen's diverse interests include travel, art collecting/painting, entertaining and cooking, dancing and good conversation. He has performed for the past 5 years in the Spectacular Follies at Dallas's Eisenmann Theater. He serves on the board of the humanitarian group KinDship, and for four years has volunteered his design talents as member of the board of Unity Church of Dallas, overseeing renovations and the Unity landscape program.

He is married to his partner of 39 years, Mr. Beau Black, who Stephen describes as a "force unto himself " in the Dallas Design Center - and life itself! Their home is ruled by two furry children, Camilla and FiFi Fiona!

To date, he has published 7 books of poetry and one children's book, "A Day in the Life of a Raindrop", with another soon to be released. His first book "A Little Boy From Nowhere Texas" won first prize in its category from the Texas Association of Authors in 2017. Stephen launched his poetry career in 2012 and to date he has composed over 2,600 poems. To be continued…

Richard Bettinger is a noted and widely recognized photographer in Dallas, Texas. He has created his own niche in the industry and captured fans with his original techniques of manipulating the camera to simulate abstract contemporary works of art which he calls Decompressionism.

He also developed and marketed his own line of wallcoverings with his partner and husband Chad Newlon Beeson, called Newlon Collection.

Richard has had a long and successful career in the Dallas Design Center at the David Sutherland Inc. design showroom.

Bettinger Studio has produced outstanding images that now grace the walls of prominent hotels nationally and internationally, famous boutiques, corporate offices and some of the most elite and fabulous homes and palaces in the world.

With their love for travel and their creative eye, Richard and Chad have also captured stunning images and unforgettable pictures from all over the country that inspire, and haunt the mind and memory.

CPSIA information can be obtained at www.ICGtesting.com
Printed in the USA
LVIW010905221120
672355LV00001B/1